Belle Chesler

W9-BUO-917

Tibetan Portrait

THE POWER OF COMPASSION

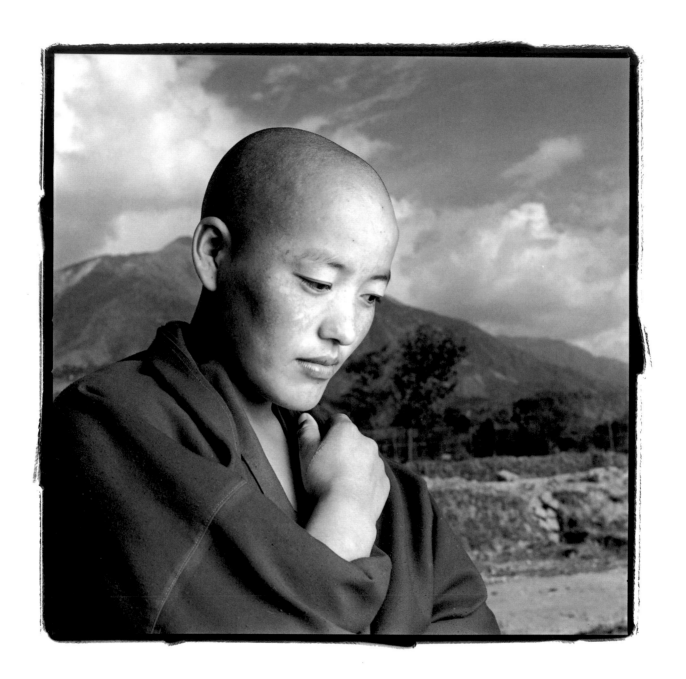

Tibetan Portrait

The Power of Compassion

Photographs by Phil Borges

Text by His Holiness the Dalai Lama

Prologue by Jeffrey Hopkins

Epilogue by Elie Wiesel

RIZZOLI
NEW YORK

First published in the United States
of America in 1996 by
Rizzoli International Publications, Inc.
300 Park Avenue South,
New York, New York 10010

Tibetan Portrait copyright © 1996
by Rizzoli International Publications, Inc.

Photographs © 1996 Phil Borges
Quotes by the Dalai Lama © His Holiness the
Dalai Lama

All rights reserved. No part of this publication may
be reproduced in any manner whatsoever without
permission in writing from Rizzoli International
Publications, Inc.

Library of Congress Cataloging-in-Publication Data

Borges, Phil.
 Tibetan Portraits: the power of compassion/
Phil Borges; text by His Holiness the Dalai Lama;
prologue by Jeffrey Hopkins; epilogue by Dr. Elie
Wiesel. p. cm.
 ISBN 0-8478-1957-4 (hc)
 1.Tibet (China)–Pictorial works. 2. Buddhism–
China–Tibet–Pictorial Works. 3.Tibet (China)–
History–1951–Pictorial Works. I.Bstan-'dzin-
rgya-mtsho, Dalai Lama XIV, 1935– II. Title
DS786.B68 1996
951'.5–dc20 95-49939
 CIP

Frontispiece: Ngawang, 22, Dolma Ling Nunnery,
India. Ngawang's lifelong desire was to become a nun,
but she could not because of the restrictions set in
Tibet. When she learned of the religious freedom and
educational possibilities that were available in India
she made the difficult decision to leave her family and
home. She said, "It is terrible, but I could not be a true
Tibetan if I stayed in my own country."

Book design by Werkhaus Design
Printed and bound in Italy

This project would not be possible without the
support of the Tibetan Rights Campaign. The TRC is
a member of an international network of organizations
working to expand and deepen the awareness of the
culture, history, and religion of Tibet. TRC works to
focus international attention on the current conditions
in Tibet and to advocate the Tibetan people's struggle
for human rights, democracy, and independence.

For information on how to participate in the work
to save Tibet, direct inquiries to:
Tibetan Rights Campaign
P.O. Box 31966, Seattle, WA 98103
Tel.: (206) 547-1015 Fax: (206) 547-3758
E-mail: <trcseattle@igc.apc.org>

Tony Stone Images is one of the largest international
stock photography agencies. If you are interested in
licensing any images featured in this book, please call
(800) 234-7880.

Reprinted in 1997

Acknowledgments

I would like to thank the following very generous and gifted friends for their contribution of support and guidance: Julee Geier, Kunzang Yuthok, Dan Hodel, Thubten Chodron, John Burgess, Steve Barrett, Beth Walker, Andrea Dietzel, Elizabeth Wales, Sarah Stone, Manuela Soares, Deanne Delbridge, Natalie Fobes, Eric Lawson, Marita Holdaway and Mary Grace Long.

A special thanks to His Holiness the Dalai Lama and the people of Tibet whose tolerance and patience in the face of conflict inspired this book.

Dedicated to Julee, Stacie, and Dax.

Tony Stone Images is honored to join Phil Borges in his tribute to the people of Tibet. We hope these portraits allow you to experience the beauty, along with the pain, of the enduring Tibetan culture.

Prologue

Jeffrey Hopkins

Compassion is the essence of Tibetan culture. For centuries, the more than six thousand monasteries and nunneries in Tibet served as wellsprings for the culture – teaching the value of compassion and techniques for generating it. The main deity of Tibetan Buddhists is Avalokiteshvara, the personification of the compassion of all Buddhas. The Dalai Lamas are considered to be incarnations of Avalokiteshvara, whose *mantra, oṃ maṇi padme hūṃ*, is on the lips and in the minds of all Tibetans. The six syllables of this *mantra* represent the six types of beings – gods, demigods, humans, animals, hungry ghosts, and hell-beings. The term *mantra* means "mind protection" and thus repetition of the mantra is aimed at protecting and purifying the mind of all beings of counterproductive tendencies such as jealousy, ignorance, anger, hatred, lust, and pride. In Tibetan Buddhism, dedication to the welfare of others is paramount. From a young age, Tibetans are taught a series of contemplative reflections for broadening and deepening compassion. In the process, practitioners contemplate:

Equanimity

Just as I want to avoid even slight pain and gain even slight happiness, so neutral persons, friends, and enemies equally want to avoid even slight pain and gain even slight happiness. They are equally bereft of happiness; they are equally beset by suffering; what they want and are engaged in are equally at cross-purposes; and thus from their own side they are all equal. Also, over

the course of lifetimes, they have equally helped and harmed me; thus from my side they are all equal. Consequently, there is no point in generating one-pointed lust or hatred toward them.

Recognition of everyone as friends
Over the course of beginningless lifetimes, friends, neutral persons, and enemies have been my best of friends countless times in countless places in countless ways. When they were my best of friends they tenderly protected me in numerous ways. At other times, when they were not my best of friends, and even when they had no motivation to help, their kindness in providing goods and services that I used was very great.

Intention to repay their kindness
I should repay this debt not just in superficial ways, but in deep ways, providing what they want, final happiness.

The advantages of cherishing others
All the suffering in the world arises from cherishing oneself; all the happiness in the world arises from cherishing others. It is right to cherish others because of their great kindness. Therefore, they are even more precious than wish-granting jewels.

Within compassion, taking away suffering
How nice if all beings were free from suffering and its causes! May they be free from suffering and its causes! I will free them from suffering and its causes!

Within love, giving away happiness
How nice if all beings had happiness and its causes! May they have happiness and its causes! I will cause them to have happiness and its causes!

Altruistic resolve to reach enlightenment
I will achieve highest enlightenment in order to help all beings.

This is the type of practice that was transmitted for centuries throughout the Tibetan cultural region, stretching from the Kalmyk Mongolian areas near the Volga River and the Caspian Sea in Europe, to Outer and Inner Mongolia and the Buryat Republic of Siberia, as well as through Bhutan, Sikkim, Ladakh, and parts of Nepal. In all of these areas, Buddhist ritual and scholastic studies

were conducted in Tibetan. Until the Communist takeover, youths came to Tibetan monasteries from throughout these vast regions to learn Buddhist practices, returning to their lands only after completing their studies. Now, however, Tibetans from the northeastern province of Amdo (currently called Qinghai by the Chinese) are not allowed entry into monastic colleges in central Tibet. They are told by the Chinese authorities that they are not "Tibetans" and sent away.

Tibet itself is actually about 25 percent of the landmass of China, but the Chinese government has absorbed at least one-third of Tibet into Qinghai, Gansu, Sichuan, and Yunnan provinces. Tibet is also being swamped with Chinese immigrants such that Tibetans have become a minority in their own land. Chinese is now the official language of the government and the main language used in all Tibetan schools.

Monasteries and nunneries are kept at artificially low numbers by the Chinese Bureau of Religious Affairs. For example, there are currently 500 students, faculty, and staff at a monastic university in the capital, Lhasa, where before the invasion there were 10,000. Of the 6,200 monasteries and nunneries that existed prior to the Chinese invasion, only a handful survived the Cultural Revolution. Tibetan buildings are being systematically destroyed and replaced by tacky commercial establishments. The aim is the destruction of a cultural identity. We cannot let this continue.

Just as Tibet before the Chinese invasion served as a beacon of hope and a source of positive attitudes in central Asia, it should again become a reservoir of teachings on mercy for the entire world – a world that has learned the results of experiments that put brutal state control over the welfare of its members or that elevate self-centered greed as the guiding principle. Just as we need the varieties of plants, so we need a diverse variety of cultures. Tibet consciously seeks to survive in order to convey, through teaching and example, a caring heart.

As the present Dalai Lama says, "Kindness is society." Without kindness, society cannot function. Tibet *must* survive.

Introduction

Phil Borges

My first awareness of the conditions in Tibet came to me via a bumper sticker –
"Free Tibet!" From whom or what, I wondered. It wasn't until I picked up a book
about vanishing cultures that I began to find out. Invaded by Chinese forces
under Mao Tse-Tung in 1949, Tibet has remained under China's occupation to
this day. This tragedy has resulted in the deaths of over twenty percent of the
Tibetan population and the near extermination of their unique Buddhist culture.
Much of Tibet's original territory has been annexed into neighboring Chinese
provinces. Today, only central Tibet (U-Tsang) and parts of eastern Tibet (Kham)
remain as the so-called Tibetan Autonomous Region (T.A.R.), which has no real
autonomy.

The more I learned about the plight of the Tibetan people, the more I wanted
to get involved. My initial idea was to create an exhibit portraying this epic
human-rights struggle through the eyes of the people involved – the Tibetans who
remain in Tibet and those who have fled to neighboring India and Nepal. With
this idea in mind, in early 1994 I traveled to northern India to the town of
Dharamsala, currently the home of the Dalai Lama, the spiritual head of Tibet,
and the Tibetan government-in-exile. Within a few days I started taking
photographs of Tibetan refugees. I was shocked to find that nearly everyone
I photographed had histories that included imprisonment, torture, or the death
of family and friends before escaping Tibet.

While in Dharamsala, I attended the outdoor public teachings the Dalai Lama gives once a year. I sat with a small group of westerners surrounded by an audience of several hundred Tibetans. Listening to the translation I was astounded to hear the Tibetan leader state that we should treat our enemies as "precious jewels," since it is our adversaries who give us our greatest opportunities to deepen our patience, tolerance, and compassion. I remember thinking, "What good is patience and tolerance if the very people who are practicing it are being systematically wiped out?!"

Two months later I entered Tibet. Although I managed to enter alone, travel is officially restricted to groups with preapproved itineraries and Chinese guides. Despite being able to travel freely, I experienced countless searches at checkpoints, saw numerous convoys of military movements, and noticed many strategically placed surveillance cameras.

The people inside Tibet seemed a bit more cautious than their refugee counterparts. While most agreed to let me photograph them, for their protection and mine, I did not ask nor did they offer any information about their lives under the Chinese occupation.

Both in and out of Tibet, I found the people in general very generous and forgiving. Often I heard the refugees I spoke with (many of whom had experienced unbelievable torture while in prison) say, "I no longer have anger for the Chinese." I heard it enough that I began to recognize the Tibetan phrase before I heard the translation.

The remarkable lightness and joy that radiated from the Tibetans I met had a profound effect upon me. They were constantly singing, laughing, and joking and seemed to be having a good time despite their difficult past and present circumstances.

All this and more fired my curiosity into investigating their ancient cultural beliefs. I am now beginning to understand why they believe it is wise to treat enemies as "precious jewels." To understand the Tibetan commitment to compassion and nonviolent effort even in the face of brutal aggression, one must examine their Buddhist worldview and values.

For the Tibetan Buddhist, peace of mind is a fundamental lifetime goal. They are taught to value contentment, fulfillment, and mental peace above all else, since one's state of mind is believed to be the only possession that survives from one lifetime to the next.

Devoting time to acquiring wealth, fame, status, or power in order to find peace and fulfillment is considered very ineffective. They believe that lasting peace of mind can only be achieved by carefully paying attention to and taking control of their motivation.

The motivation responsible for most dissatisfaction and suffering is considered to be self-grasping, also known as self-cherishing. Referred to as "the greatest enemy," this attitude is rooted in ignorance. Ignorance that leads us to see everything – ourselves, others, all phenomena – as solid and separate. It keeps us from realizing that everything is actually very interdependent and connected – that our well-being depends upon the well-being of everything and everyone around us.

Compassion is at the core of the Tibetan Buddhist culture. The Tibetan Buddhists believe that there is no greater vehicle than compassion and forgiveness to counteract the suffering caused by the self-grasping attitude. This attitude is slowly dissolved by the daily cultivation of compassion. For them to abandon their commitment to this ideal in response to an aggressor would be tantamount to abandoning the culture they are struggling to save. However, to be compassionate and forgiving does not imply passivity to them. They believe that using compassion in the face of conflict or aggression is to decide to act without the motivation to harm or retaliate – to act in a way that will best serve all individuals involved.

The Tibetans continue to work to save their unique culture and to regain their country. Their internal struggle as human beings is to try to reconcile the nonviolent principles of their most cherished beliefs with the rage that can arise when harmed. It is an extreme test of their commitment to compassion, to their religion and culture.

Here are some of the people I met – men, women, and children, from the nomads of the remote Himalayas to the Dalai Lama himself – each and every one of them committed to their religion, their culture, and to the practice of compassion.

I am serving the Tibetan cause with the
motivation of service to humankind,
not for reasons of power, not out of hatred.
Not just as a Tibetan but as a human being,
I think it is worthwhile to preserve that culture,
that nation, to contribute to world society.

We Tibetans have an equal right to
maintain our own distinctive culture as long
as we do not harm others.
Materially we are backward, but in
spiritual matters — in terms of the development
of the mind — we are quite rich.

I am often asked about my Buddhist religion.
Most simply, it is the practice of compassion.

His Holiness the Fourteenth Dalai Lama

From the moment of birth

every human being wants happiness and

wants to avoid suffering.

In this we are all the same.

Jigme 8, Sonam 18 months
Ladakh, India

Jigme and Sonam are sisters whose nomadic family had just come down from the Himalayan highlands to their winter camp on the Changtang, or Tibetan Plateau, at an altitude of 16,500 feet. When I gave Jigme a Polaroid of herself she looked at it, squealed, and ran into her tent. It must have been the first time she had seen herself since her family did not own a mirror.

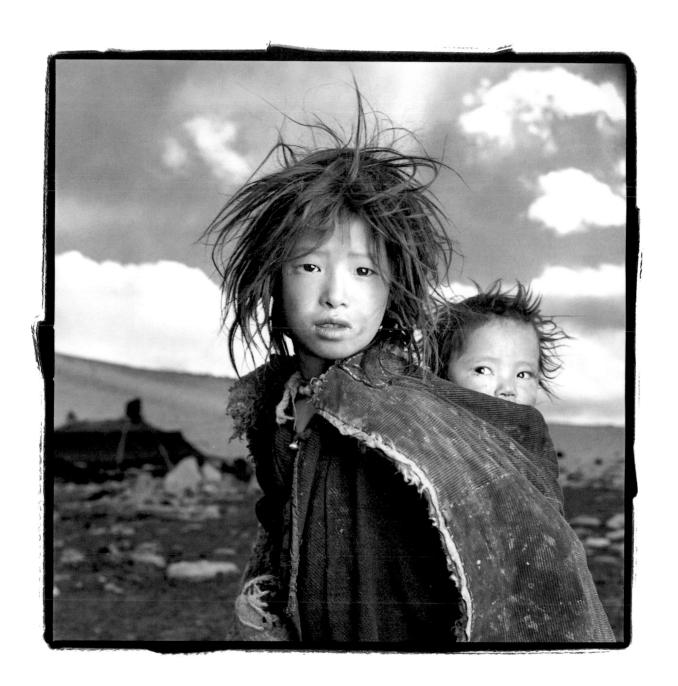

Whether one believes in a religion or not,

and whether one believes in rebirth or not,

there isn't anyone who doesn't appreciate

kindness and compassion.

Namgyal 13, Thuman 16
Dharamsala, India

Although Thuman and Namgyal were in a monastery, their parents felt they could get a better education and retain more of their culture if they left Tibet. Like hundreds of children every year, they said good-bye to their parents not knowing if they would ever see them again. They were then smuggled out of Tibet over the Himalayas and into India.

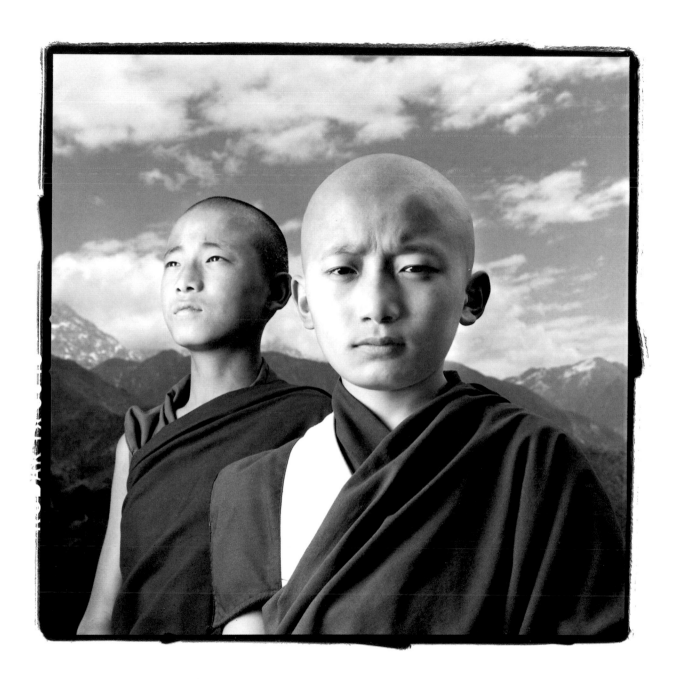

Our self-centeredness,

our distinctive attachment to the feeling

of an independent "I" works to inhibit

our compassion.

True compassion can only develop

and grow as such self-grasping is reduced

and eventually eliminated.

Tamdin 69
Dharamsala, India

Tamdin was imprisoned and tortured for taking part in a demonstration in Lhasa in 1987 protesting the occupation of Tibet. Recently she escaped across the Himalayas, walking for thirty-five days to seek refuge and an audience with her spiritual leader the Dalai Lama. When I took this photo of her three days after she had arrived in India, she was still wearing the same beat-up tennis shoes that had taken her across the mountains.

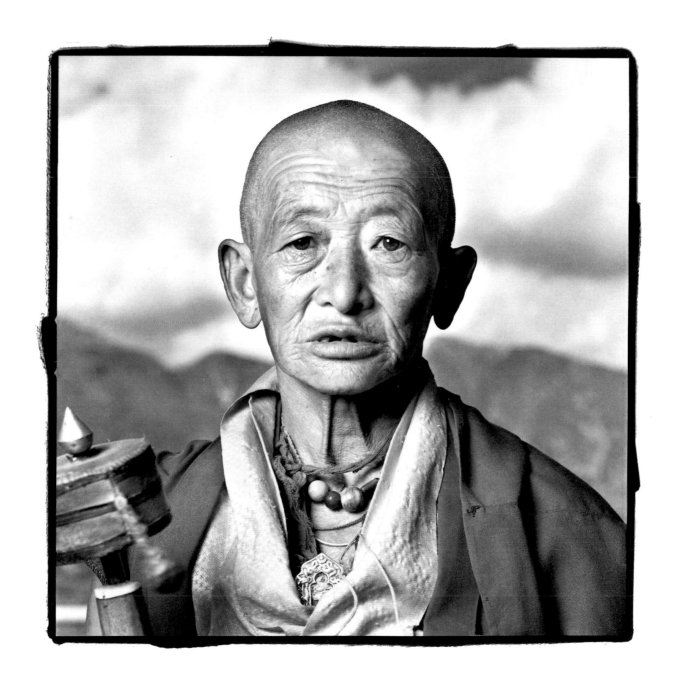

The reason why love and compassion bring
the greatest happiness is simply that our nature
cherishes them above all else.
The need for love lies at the very foundation
of human existence.
It results from the profound interdependence
we all share with one another.

Pemba 4
Trak Tok, Ladakh

Pemba had come to the little village of Trak Tok with her mother and sister to see the highly elaborate and beautiful *shum* dance festival on this sunny but bitterly cold December day. She caught my eye in the crowd because of her look of fascination and total concentration on the dancers. She seemed to be transfixed during the entire ceremony in spite of the constant cold wind.

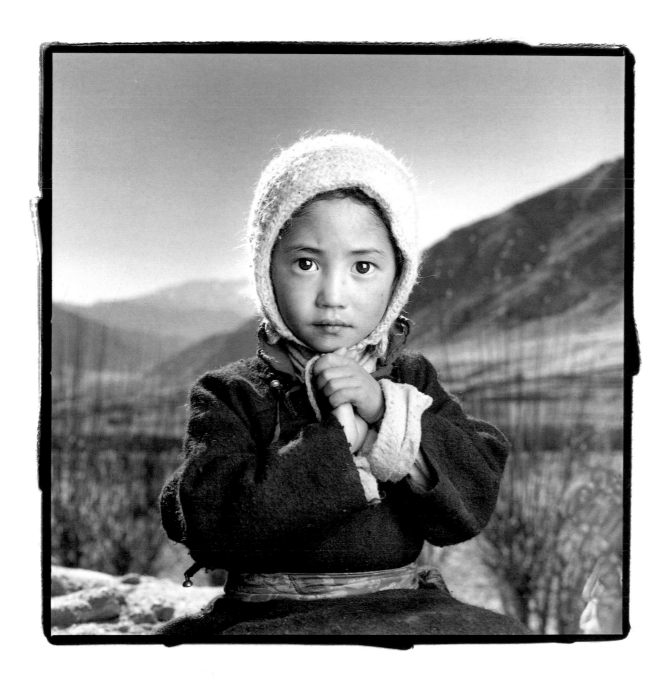

Many times I am asked if I am angry at

the Chinese for what has happened.

Sometimes I lose some temper, but afterwards

I get more concern, more compassion

towards them. In my daily prayer, I take in

their suffering, their anger,

and ignorance…and give back compassion.

This kind of practice I continue.

Tenzin Gyatso 59
Dharamsala, India

Born to a peasant family, he was discovered to be the reincarnation of the Buddha of Compassion at the age of two. At four he was installed as the fourteenth Dalai Lama and then as a teenager he faced the invasion of his country. Eight years later he was forced to flee to neighboring India, where he still lives. Our appointment for this portrait was set for the afternoon on the rooftop of his residence. As he approached, I nervously held out my hand to greet him. He avoided it, stuck his fingers in my ribs, let out his famous laugh, and tickled me.

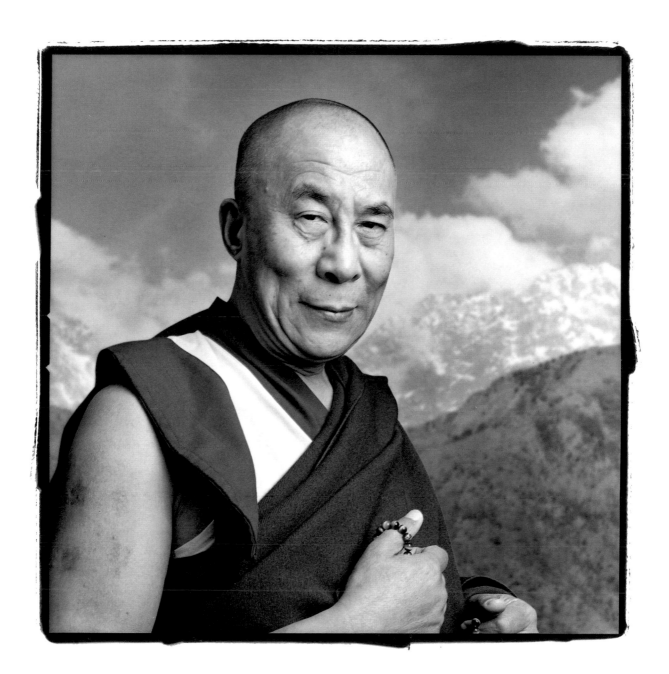

With kindness, with love and
compassion, with this feeling that is the
essence of brotherhood, sisterhood,
one will have inner peace.
This compassionate feeling is the basis of
inner peace.

Shelo 20; Benba 17
Nyalam, Tibet

Shelo and Benba, best friends since childhood, are currently working as hostel maids in Nyalam, an old
Tibetan village that has recently become a stopover for climbers on their way to Mt. Everest. As Tibetans,
they are rapidly becoming an insignificant minority in their own country because of the massive influx of
Chinese into Tibet.

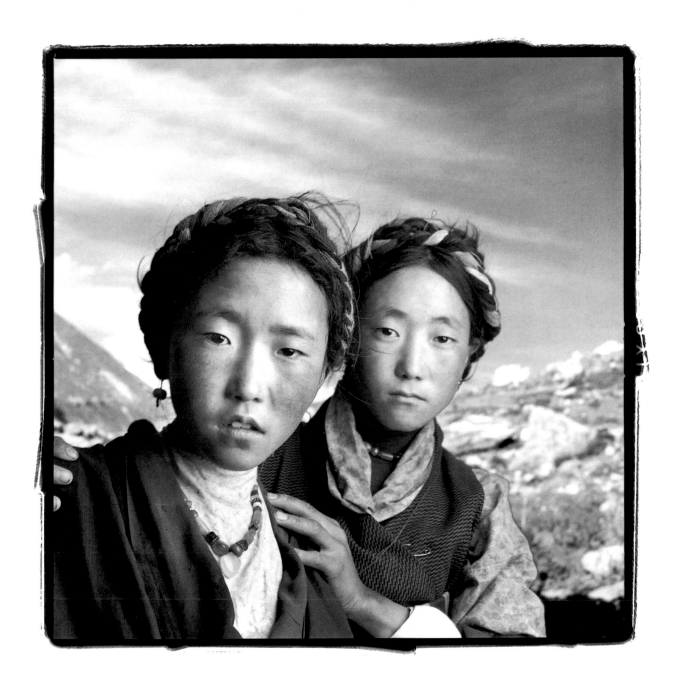

Brute force, no matter how strongly applied,
can never subdue the basic human desire for
freedom.

Kalsang 25, Ngawang 22, Dechen 21
Dolma Ling Nunnery, India

These nuns had just arrived at the Dolma Ling Nunnery in India after fleeing Tibet. In 1992 they were arrested, beaten, shocked with electric cattle prods, and imprisoned for two years for protesting the occupation of Tibet by putting up posters in Lhasa. Several times while talking, Dechen broke into tears, quietly excused herself, and then continued relating her story.

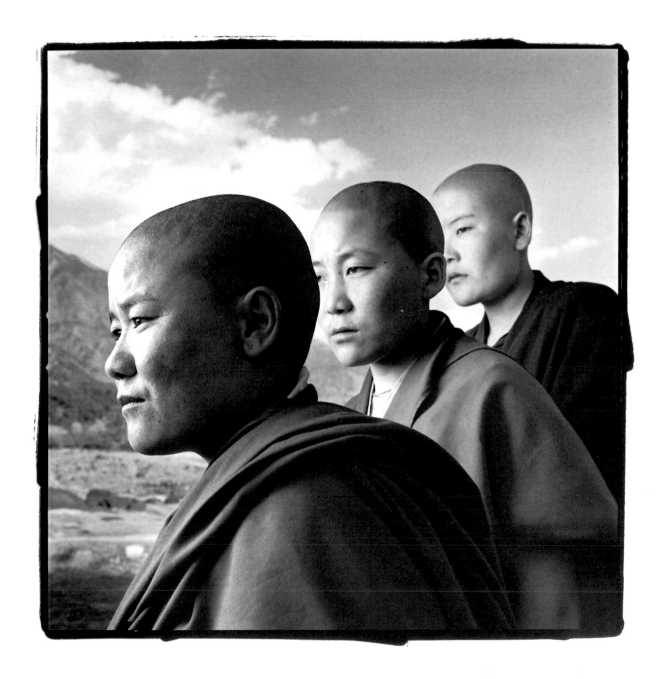

The more we care for the happiness of others,

the greater our own sense of well-being becomes.

Ngoedup 54, Wangchuk 7
Kathmandu, Nepal

Seven-year-old Wangchuk walked steadily for twenty-two days alongside his father over the Himalayas to escape Tibet. Ngoedup came to put his son in school and see the Dalai Lama. Having just reached the refugee camp for new arrivals in Nepal and not being accustomed to the lower altitude, they were exhausted and badly insect-bitten.

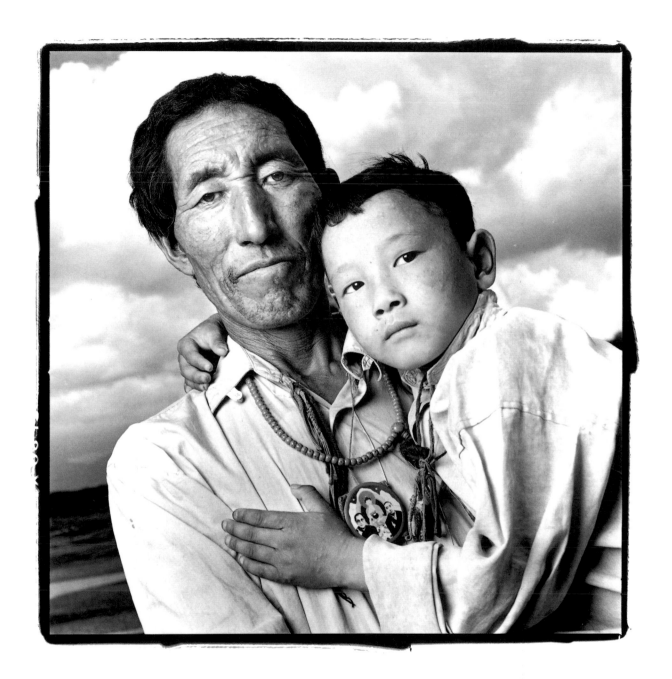

Anger and hatred are our real enemies.

These are the forces we most need to confront

and defeat, not the temporary "enemies"

who appear intermittently throughout life.

Palden 62
Dharamsala, India

Palden was arrested at his monastery in 1959 and spent twenty-four years in prison, where he was tortured frequently – losing twenty teeth in one beating. He managed to flee Tibet in 1987 and came to Dharamsala. He told me, "I no longer have anger for my captors. However, I feel it is my responsibility to let the outside world know what is happening in Tibet"

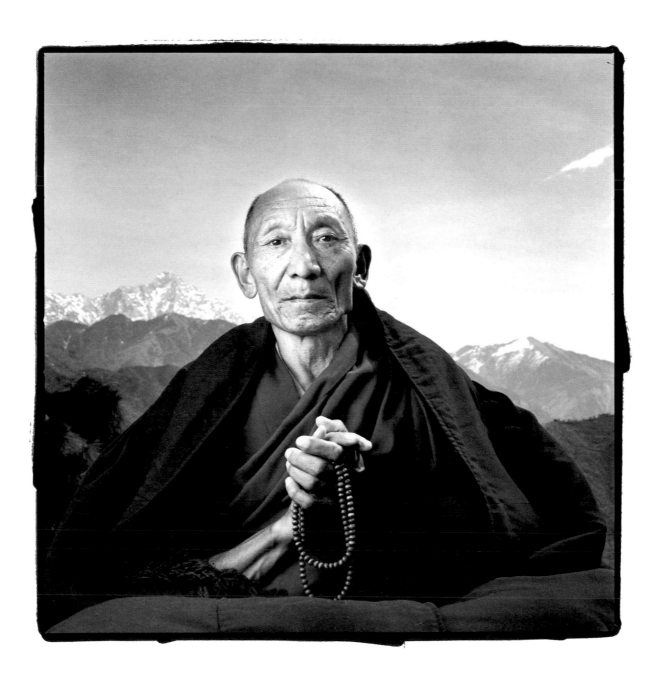

Since at the beginning and end of our lives

we are completely dependent on the kindness of others,

how can it be that in the middle we would neglect

kindness toward others?

Ahidha 10 months, Sonam 21 months
Lhasa, Tibet

Ahidha and Sonam are Muslim children who live near their mosque in Lhasa, the capital city of Tibet. Muslims have peacefully lived alongside Tibetan Buddhists for centuries and there are currently thousands of Muslims living in Tibet. Their religious practices are strictly controlled by the Chinese Bureau of Religious Affairs.

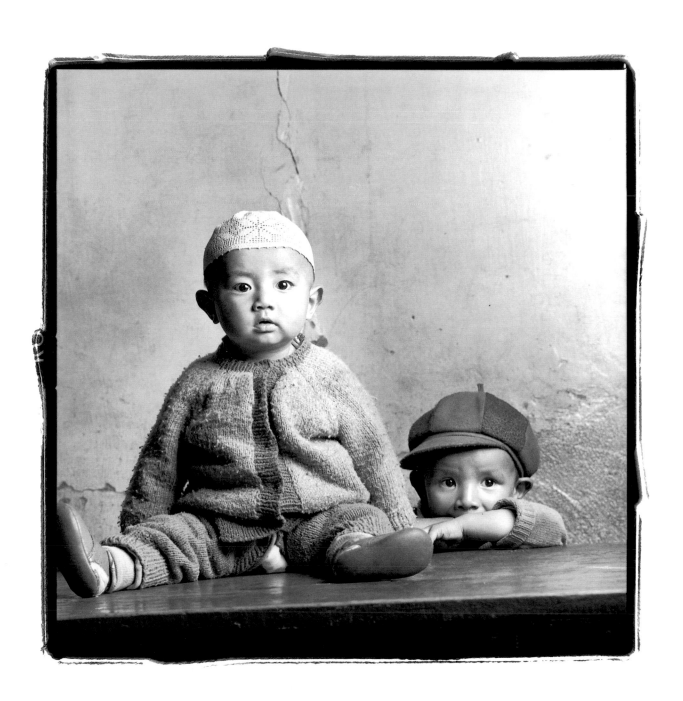

Changes in attitudes never come easily.
The development of love and compassion
is a wide, round curve that can
be negotiated only slowly, not a sharp corner
that can be turned all at once.
It comes with daily practice.

Tempe 40
Dharamsala, India

Tempe decided to leave Tibet in order to continue his religious training and to be close to his spiritual leader the Dalai Lama. He had been in Dharamsala about a month and was planning to begin a lifelong solitary retreat the day after this photo was taken. He said his retreat was not to escape from the world, but to transform his mind so he could serve more effectively in heightening the consciousness of the world today and in future lifetimes.

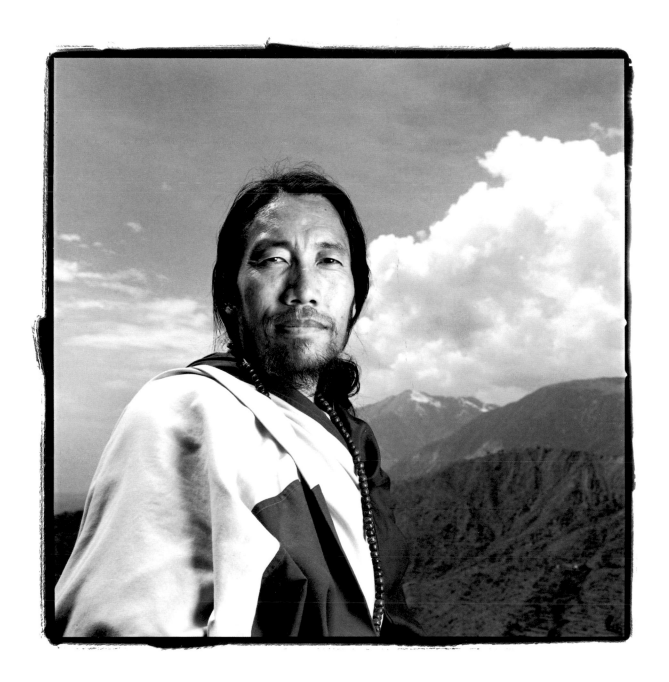

I try to treat whoever I meet as an old friend.

This gives me a genuine feeling of happiness.

It is the practice of compassion.

Lobsang 67, Tensin 13
Bodhnath, Nepal

Lobsang and sixty-six fellow monks were imprisoned in 1959. Released twenty-one years later, he was one of only three survivors. While in prison his best friend, a rinpoche (a high *lama*), died in his arms. Tensin was later discovered to be the reincarnation of that friend. Lobsang said there were many character-istics of his old friend in the young boy.

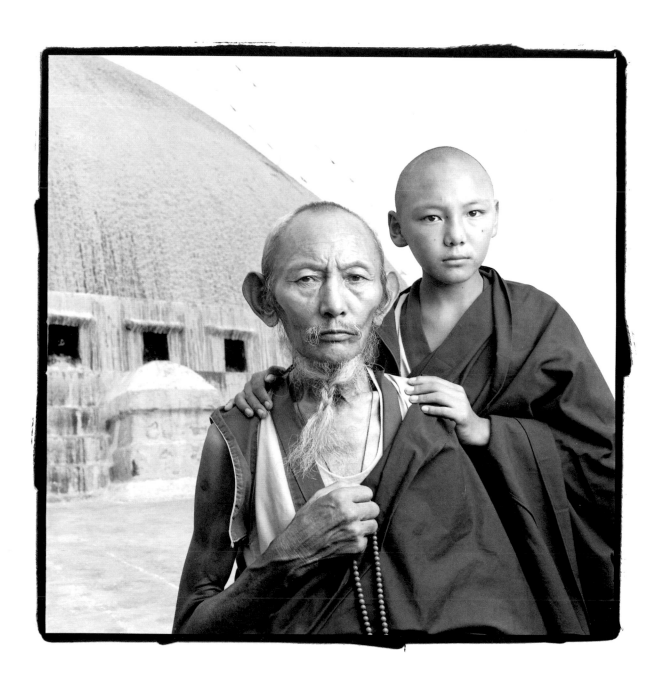

Controlled energy comes not only from
a compassionate attitude, but also from reason
and patience. These are the most powerful
antidotes to anger.
Many people misjudge these qualities
as signs of weakness. I believe just the opposite —
they are the true signs of inner strength.

Jigme 24
Bodhnath, Nepal

Jigme is from Amdo Province in Tibet, where he had been imprisoned five months for putting up posters protesting the high taxes on farmers' crops. Passing over the Nepalese border at night, he was caught by border guards, who robbed him before letting him go. He was on his way to Dharamsala where he hopes to pursue his education.

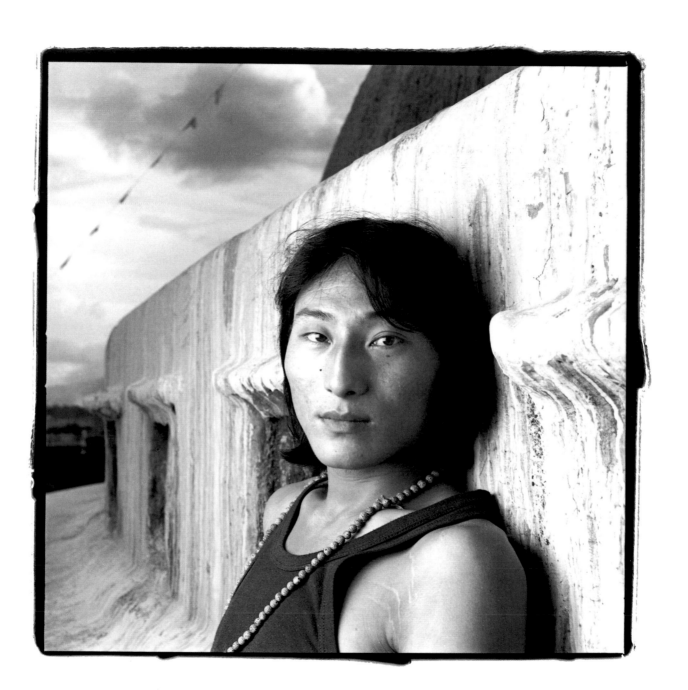

A truly compassionate attitude toward others does not change even if they behave negatively or hurt you.

Samdi 3
Lhasa, Tibet

Although just three, Samdi has the poise of someone much older. I will never forget the extraordinarily mature look in her eyes. Her father said that she is already asking to become a nun. She was praying with her father at the Jokhang Temple when I first noticed her.

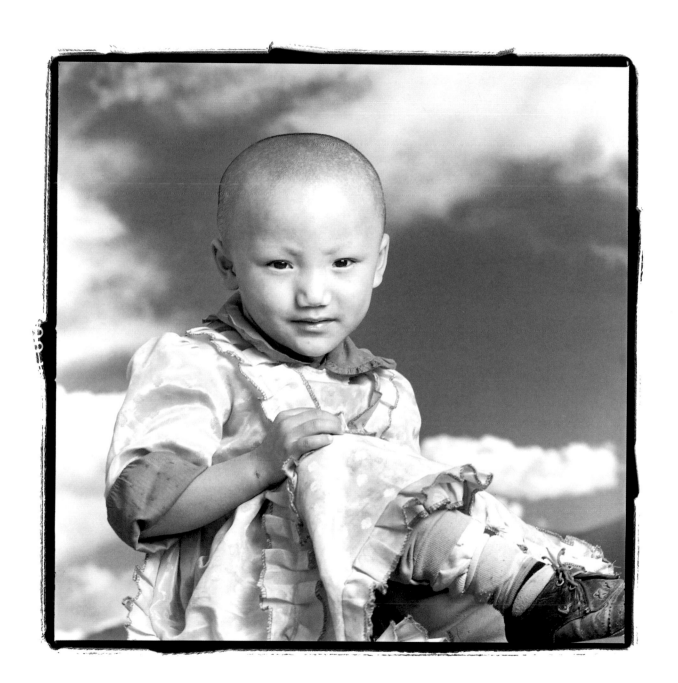

There should be a balance between
material and spiritual progress, a balance
achieved through the principles based
on love and compassion.
Love and compassion are the essence
of all religion.

Karma 63
Kathmandu, Nepal

Karma was one of several hundred nomads who fled Western Tibet in 1962 when her family got word the Chinese invaders were forcing nomads to live in communes. An older brother who stayed behind was one of thousands who starved to death the following winter when the dislocations resulted in an economic collapse. Today she is a carpet weaver living in Nepal.

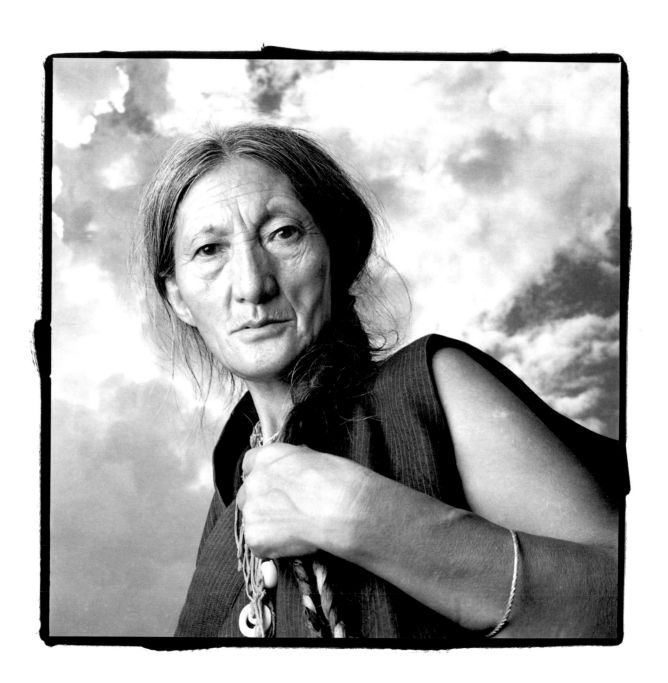

Compassion and love are precious things in life.

They are not complicated.

They are simple, but difficult to practice.

Botok 76, Tsangpa 78
Settlement Camp #1, Ladakh

Botok and Tsangpa were classified as wealthy by the Communist authorities in 1962 because they owned almost a thousand sheep and goats. Threatened with imprisonment, they fled across the border into the Indian district of Ladakh with their three daughters and Tsangpa's other husband. They told me that it is not uncommon for Tibetan women to take more than one husband.

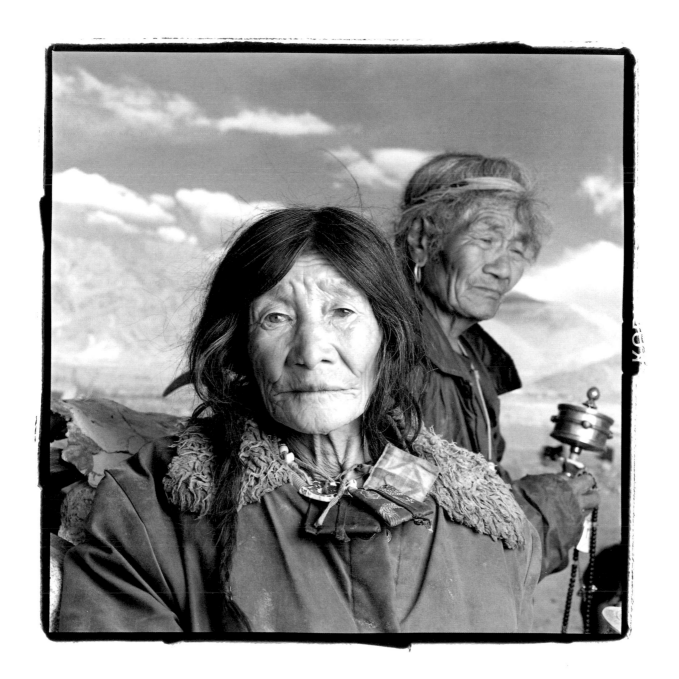

Cultivating a warmhearted feeling for others
automatically puts the mind at ease and
helps remove whatever fears and insecurities
we may have.

Dawa 15
Drigung Valley, Tibet

Dawa is a student and the eldest son of a barley farmer. Although responsible for his family's herd of goats, he spends most of his free time reading – especially anything written in Tibetan. He proudly showed me a well-worn copy of an English-Tibetan phrase book that a western traveler had given him two years before.

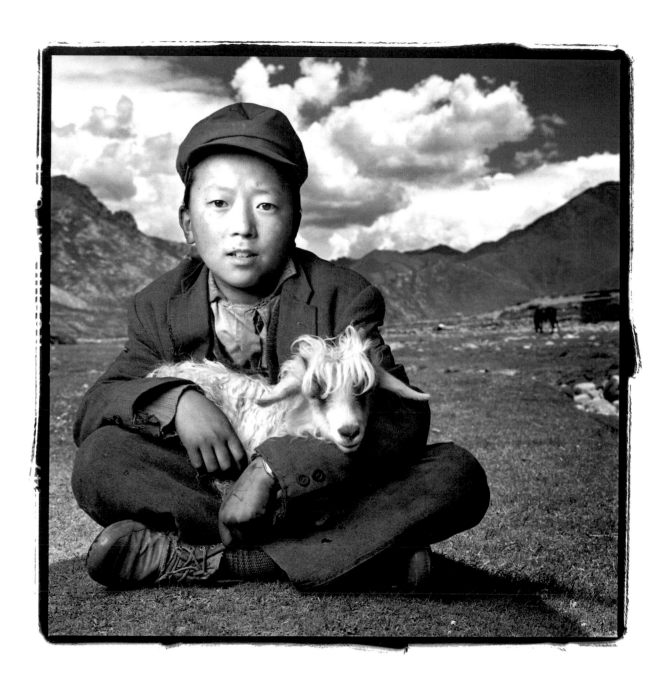

Interdependence is a fundamental law
of nature. Many of the smallest insects are
social beings who, without any religion,
law or education, survive by mutual cooperation
based on an innate recognition of
their interconnectedness.

Kunsang 29, Dechen 6 months
Jawlakhel, Nepal

Kunsang walked for twenty-five days, crossing the Himalayas with her baby boy on her back. She said, "I want him to grow up in a Tibetan culture and get a proper education. At this time this is not possible for us Tibetans in our own country." This photo was taken two weeks after they arrived in Nepal en route to India.

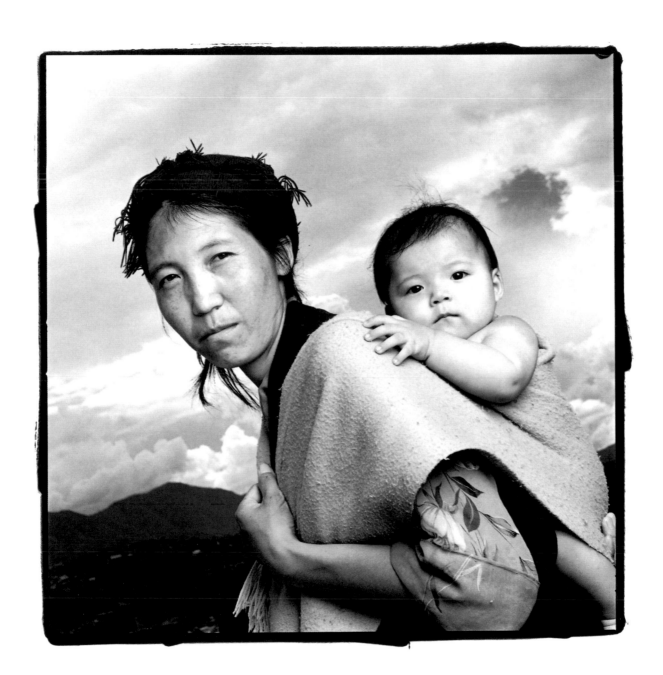

If you have inner peace, the external problems

do not affect your deep sense of tranquillity.

You are happy regardless of circumstances.

Tseten 81
Choglamsar, Ladakh

Tseten was almost 50 when he was forced to give up his large herd of goats and yaks and flee Tibet. He is now one of two thousand Tibetans living in a refugee camp near Choglamsar, Ladakh, where he has only one goat and a small plot of land to grow some vegetables. He said, "Because of my religion I am happy living anywhere."

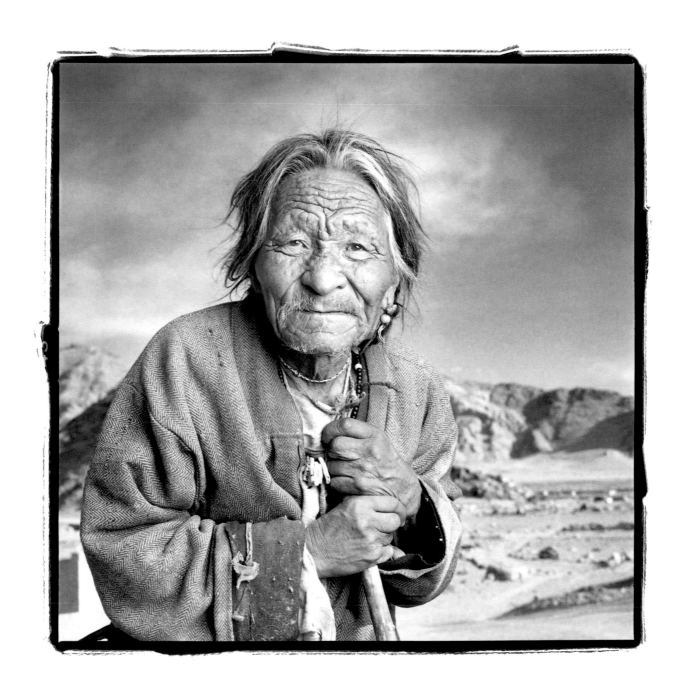

Many of our problems are created by ourselves

based on divisions due to ideology, religion, race,

economic status, or other factors.

The time has come for us to think on a

deeper level, on a human level and appreciate

and respect our sameness as human beings.

Delek 22
Dolma Ling Nunnery, India

Delek, a new arrival from Tibet, said she is very hopeful that she will be able to return to her home one day. "I want to share my true knowledge with the Tibetan people. In Tibet our parents were not allowed to teach us about our history, culture, and traditions. After I am good in Tibetan and English, I will return."

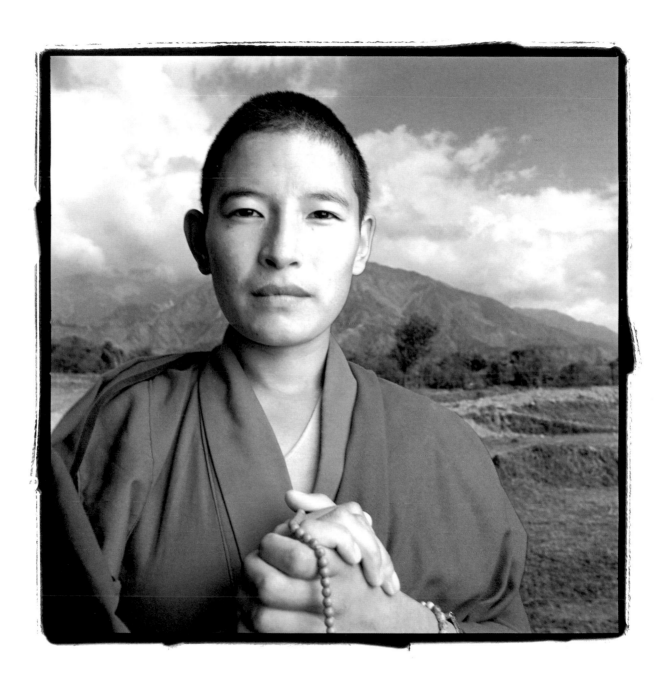

It is not enough for us

to think about how nice compassion is!

We need to make a concerted effort to develop it.

We must use all the events of our daily life

to transform our thoughts and behavior.

Dechi 8, Tsering 8
Damxung, Tibet

Tsering and Dechi are good friends whose nomadic families reside in the Yanpachen Valley. I was told that in areas such as this, wildlife was plentiful and virtually unafraid of humans due to the sacred treatment of all life by Tibetan Buddhists. Today wildlife is hard to find and many exotic species have been hunted practically to extinction.

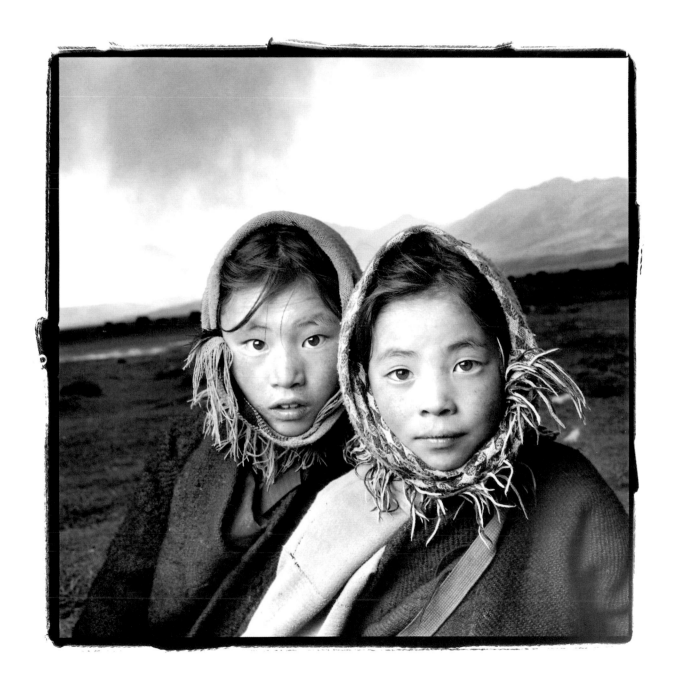

Although it is difficult to attempt to bring
about peace through internal transformation,
this is the only way to achieve lasting
world peace.
Even if during my lifetime it is not achieved,
it is all right. The next generation will make
more progress.

Norzum 44
Tso Morari, Ladakh

Norzum vividly remembers fleeing Tibet with his family as a boy. Walking at night and hiding during the day, it took over twenty days to cross the border into Ladakh. During the bitterly cold journey, at altitudes above 16,000 feet, his younger brother died. He says that the area in which he is now forced to live is much harsher than his boyhood home.

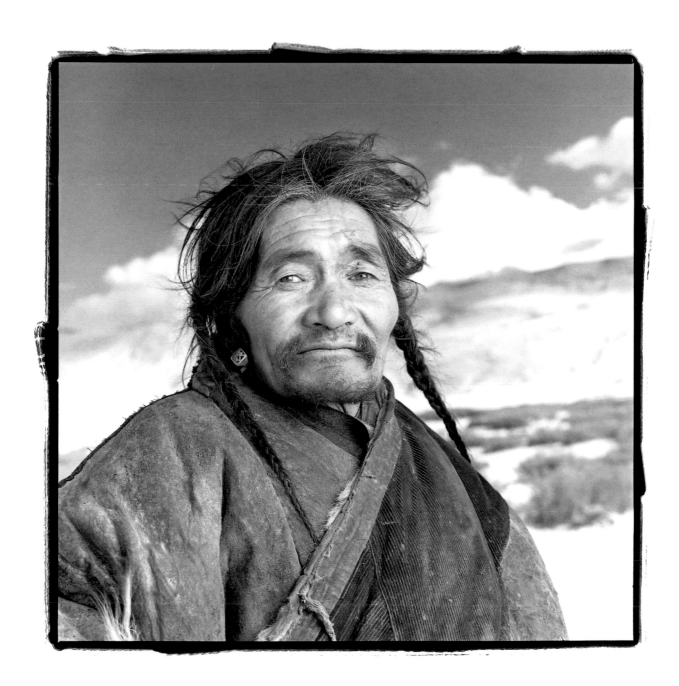

The motivation of all religious practice
is similar — love, sincerity, honesty.
If we put too much emphasis on our own
philosophy, religion, or theory and try to impose
it on other people, it makes trouble.

Samdu 11
Parka, Tibet

Samdu was stricken with a crippling malady known as "big bone disease" when she was five. Even though she does her best to help care for this rapeseed field, she has to be carried everywhere by her friends. This arthritis-like disease, which only afflicts children, is virtually unknown outside her little village.

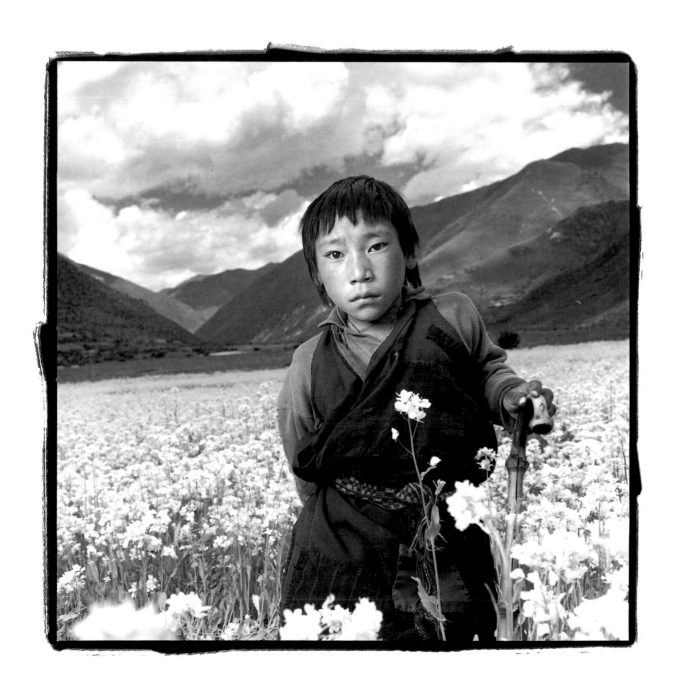

Anger, hatred, jealousy —

it is not possible to find peace with them.

Through compassion, through love,

we can solve many problems,

we can have true happiness, real disarmament.

Samdo 50, Kunga 18
Nam Tso, Tibet

Kunga was braiding her mother's hair as I walked into their camp. It was midmorning and they were just about to retrieve their goats for the morning milking. They motioned for me to join them as they waded across the ice-cold river. We each grabbed a goat by the horns and floated them back across to the camp. The rest of the herd followed.

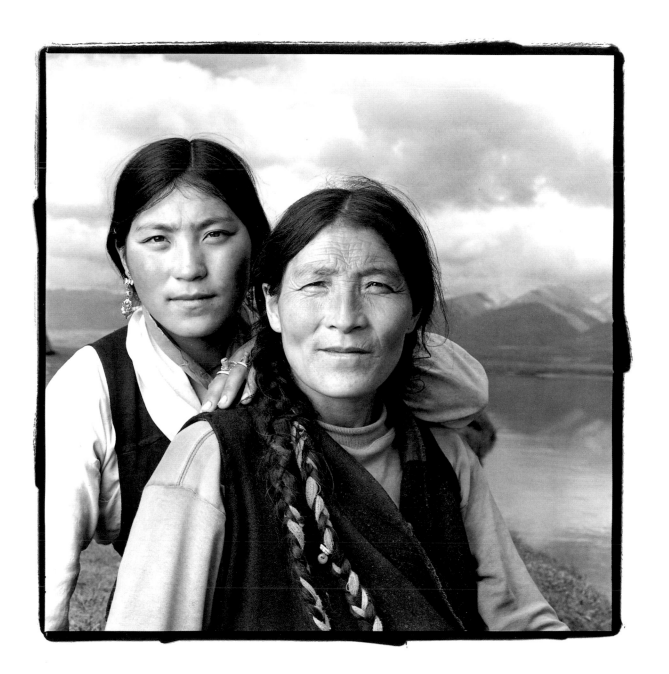

All of Buddha's teachings

can be expressed in two sentences.

"You must help others"

and "If you can't help, you should not harm others."

Chamdu 11
Tso Morari, Ladakh

Chamdu very hesitantly asked me if I had taken a photo of the Dalai Lama that she could have. She is
the eldest of four children living in a yak-hair tent with her family in this very remote and rugged area of the
Changtang, or Tibetan Plateau. Since there are no trees or bushes at this 16,500-foot altitude, the only
fuel they have to get them through the long and bitterly cold winter is goat dung.

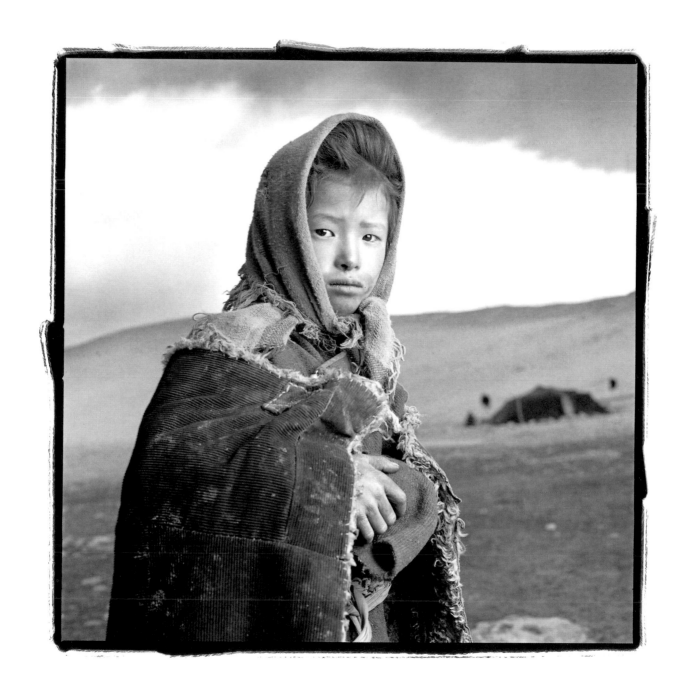

*It is not the possession of material
wealth or weapons, but whether you have
patience, compassion, and concern
for others…that is the real source of peace
and happiness.*

Namyang 51, Tsutin 56
Lhasa, Tibet

Namyang and Tsutin are farmers from Amdo Province who had just arrived in Lhasa after completing a
two-month pilgrimage to the Jokhang, the most sacred temple in Tibet. Tibetans from all over the country
aspire to make this pilgrimage at least once during their lifetime.

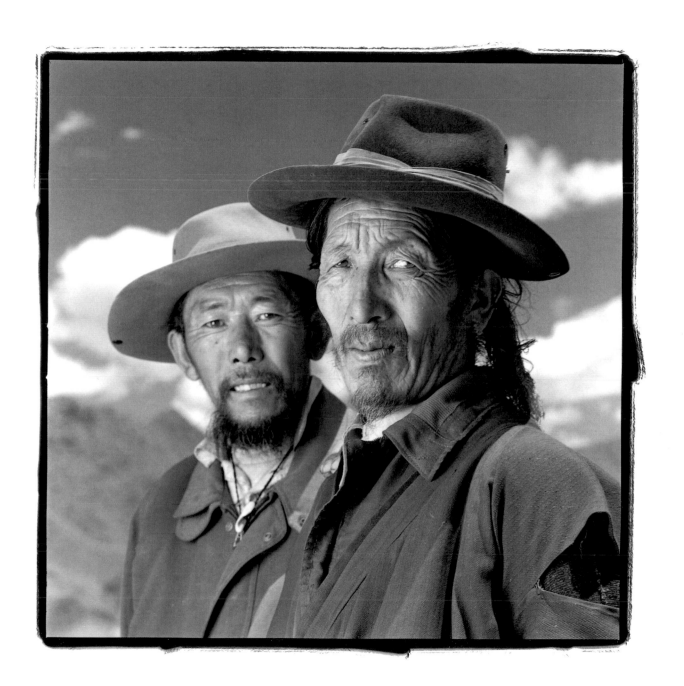

When I talk about controlling the mind,

I mean cultivating less anger, more respect for

others' rights, more concern for other people,

more clear realization of our sameness

as human beings.

Lelung 24
Dharamsala, India

Lelung Rinpoche is the reincarnation of a long line of high Tibetan lamas. Last year he was asked
by the Dalai Lama to go to Tibet and rescue the written works of his previous incarnation, the last Lelung
Rinpoche. Although the monastery had been completely destroyed, he was able to locate the writings
and get them safely out of Tibet.

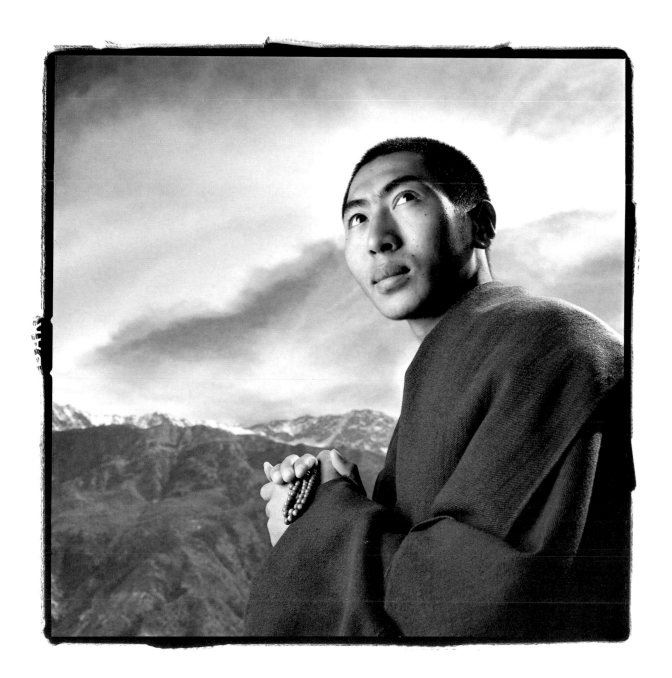

Everyone needs peace of mind.
The question is how to achieve it.

Through anger and hatred we cannot;
I believe it is most easily achieved
through the practice of kindness, love,
and compassion.

Dolma 38
Changtang, Ladakh

Dolma had never seen a westerner up close before. She would reach out, touch my shoulder, then quickly pull her arm back into her *chuba* and laugh. As a young girl she escaped across the Tibet-India border with her family after word reached their remote nomad camp that they would be forced to live in a commune.

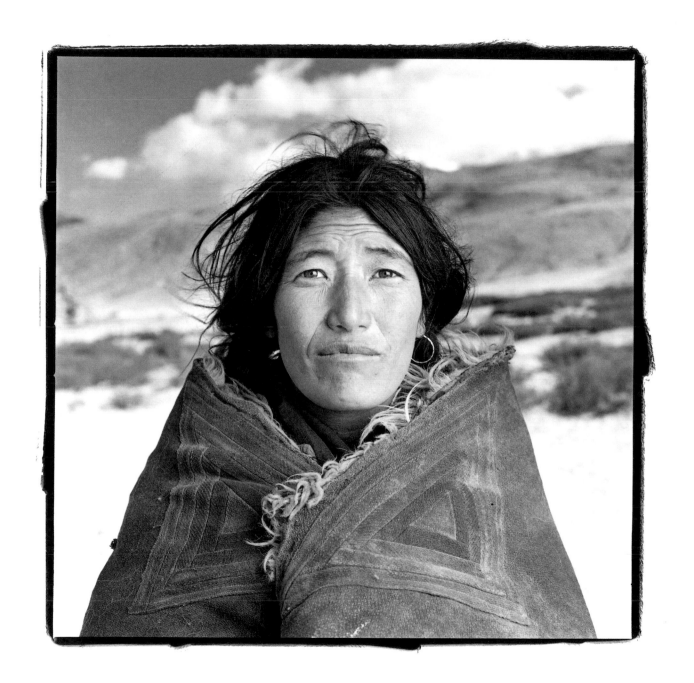

For a person who cherishes compassion and love,

the practice of tolerance is essential

and for that an enemy is indispensable.

So we should feel grateful to our enemies

for it is they who can best help us develop

a tranquil mind.

Samden 72

Ganden Monastery, Tibet

Samden came to Ganden Monastery at the age of 12. Once the pinnacle of Tibet's university-like monasteries, Ganden was completely destroyed during the Cultural Revolution along with all but 11 of Tibet's 6,200 monasteries. Samden was 44 when the ground and air bombing occurred and has recently returned to help with some of the rebuilding.

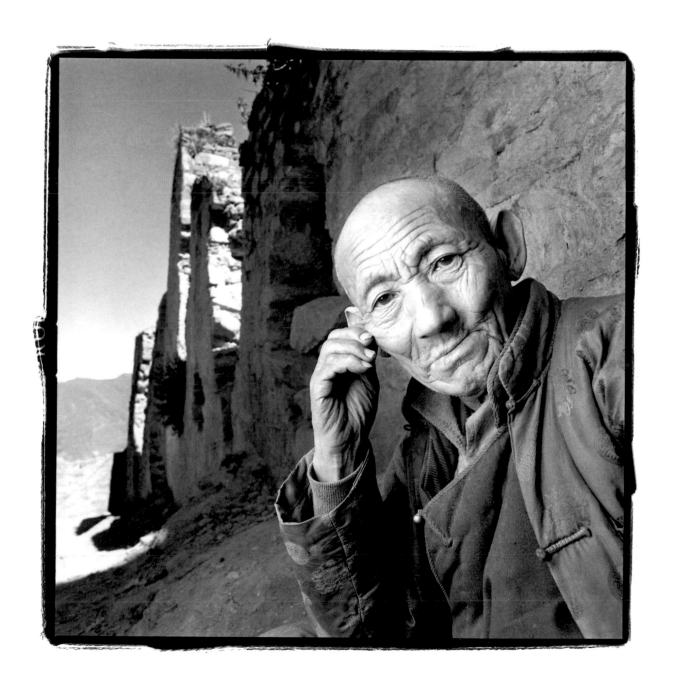

This is my simple religion:

There is no need for temples;

no need for complicated philosophy.

Our own brain, our own heart

is our temple; the philosophy is kindness.

Telang 10, Tenzing 12
Kathmandu, Nepal

Telang and Tenzing are brothers who live in a monastery very close to the stupa at Swayambunath in the Kathmandu Valley. They were born in Nepal to parents who had fled Tibet as children during the uprising in 1959. Although a few Tibetans have lived in Nepal for thousands of years, most of the 12,000 currently living there are refugees or descendants of refugees.

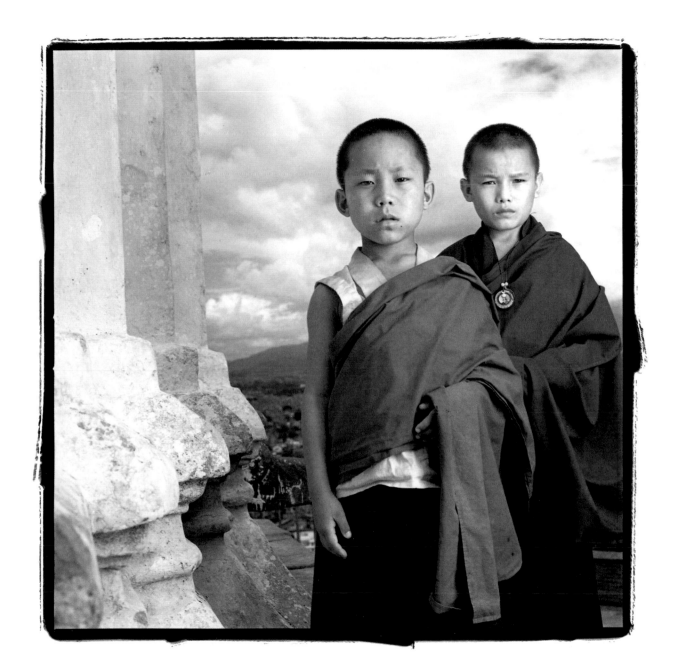

Desire and attachment are

sometimes mistaken for compassion and love.

Compassion is not dependent on someone

appearing beautiful or behaving nice.

It is based on the knowledge that the other

person is fundamentally like oneself.

It is based on reason

not just an emotional feeling.

Tsezim 78, Decky 72
Dharamsala, India

Tsezim and Decky are old friends. They were among the 100,000 Tibetans who fled from Tibet in 1959 along with the Dalai Lama. Decky's husband was killed during the uprising, but her five children escaped with her. She settled and raised her children in Dharamsala, which is currently the home of the Dalai Lama and the Tibetan government-in-exile.

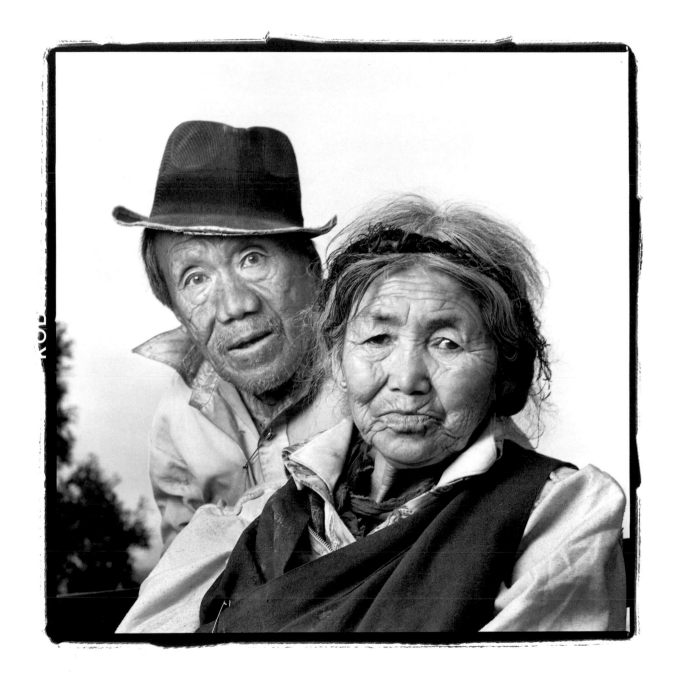

The power of compassion is its ability

to bring peace of mind, contentment, and fulfillment

regardless of external circumstances.

Kensang 51
Zhonggang, Tibet

Kensang lives in a small village about forty-five kilometers from the Tibet-Nepal border on the "friendship highway" between Kathmandu and Lhasa. The cave where the sage Milarepa spent many years of his life meditating is very near this spot. Shortly after I took this photograph two heavily armed Chinese soldiers suddenly appeared. They began shouting angrily and tore up several sheets of my used Polaroid backings.

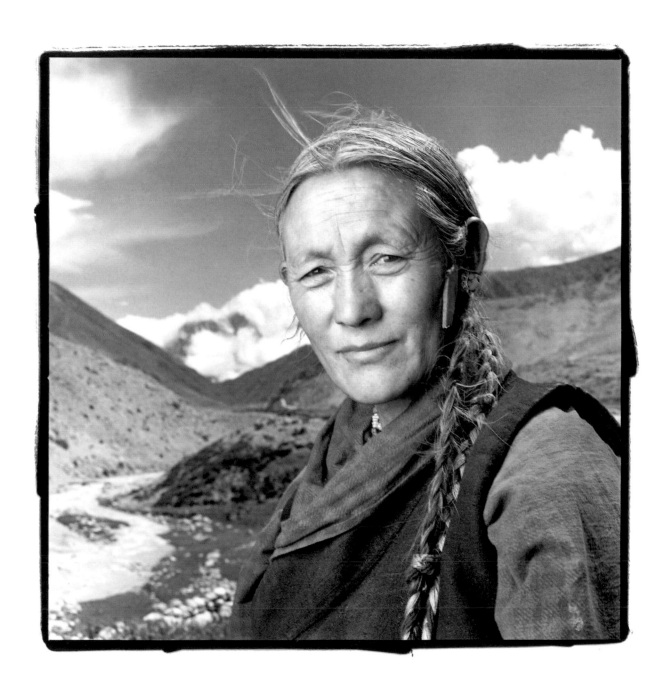

I believe that at every level of society —

familial, tribal, national, and international —

the key to a happier and more successful world

is the growth of compassion.

We do not need to become religious,

nor believe in an ideology.

Only develop our good human qualities.

Dolkar 5, Tashi 6
Dharamsala, India

Dolkar and Tashi live in the Tibetan Children's Village in upper Dharamsala along with two thousand other Tibetan children who have been orphaned or sent out of Tibet by their parents. I was told that Dolkar was an extremely sensitive child but has adapted rather well since her arrival at the children's village over a year ago. Tashi, who was orphaned as a baby, has come to be known as the joker of their class.

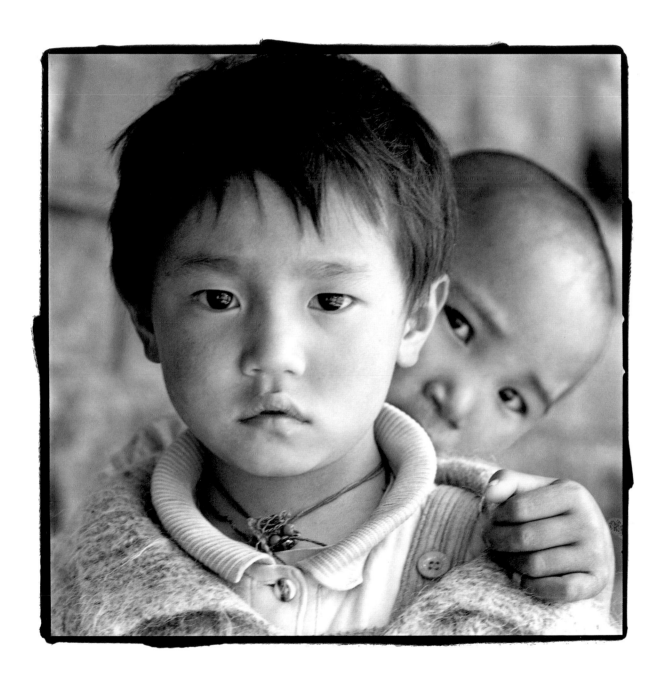

If we were aware

that we all contain love within us,

and that we could foster and develop it,

we would certainly give it far more attention

than we do.

Namyang 73
Dharamsala, India

Namyang escaped Tibet in 1959 during the national uprising against the occupation of his country.
The fighting that occurred at that time resulted in the deaths of several of his family members and eighty
thousand other Tibetans. He subsequently settled in Dharamsala where he now lives in a retirement
home very close to the Dalai Lama's residence.

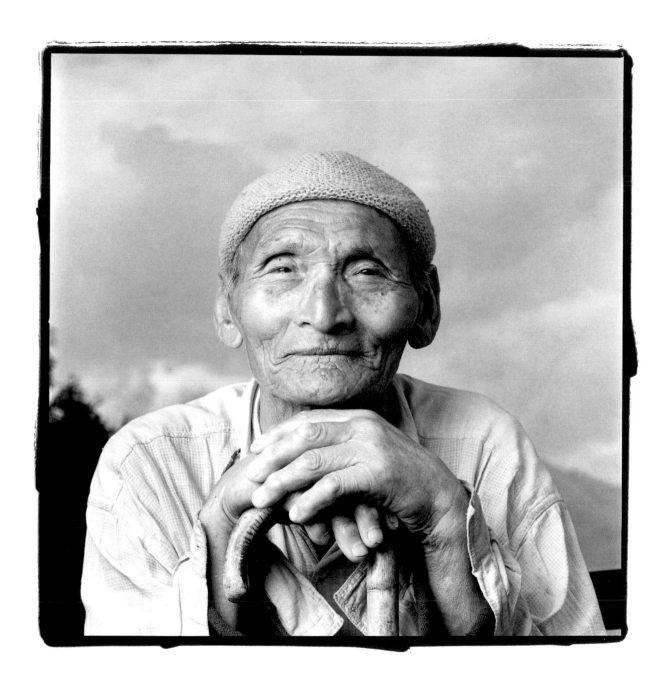

World problems cannot be challenged
with anger and hatred. They must be faced with
compassion, love, and true kindness.

Yeshi 13
Drigung Valley, Tibet

Yeshi was practicing her Tibetan script on a painted board in this small village school. I was amazed by the quality of her work. It was some of the finest calligraphy I had ever seen. Her teacher was a Tibetan who had been educated in a Chinese-run university. My interpreter told me that even though the Tibetan language was being taught, all their books on history and Tibetan culture were written from a Chinese perspective.

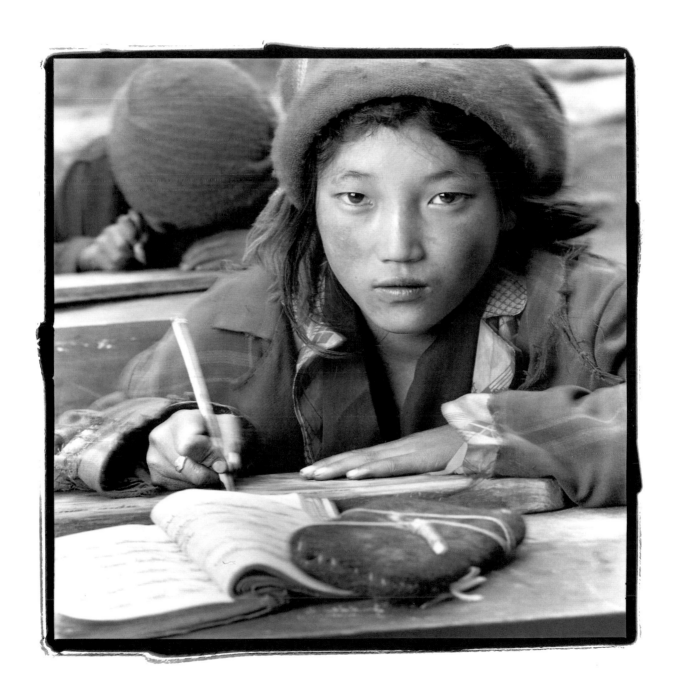

The history of this century is confirming
the nonviolence that Mahatma Gandhi and
Martin Luther King, Jr., spoke of.
Even when it is against a superpower, the reality
of the situation can compel the hostile nation to
come to terms with nonviolence.

Dolkar 72, Youdoh 74, Deckey 76
Dharamsala, India

These women are old friends, having met after they fled Tibet with their families shortly after the Dalai Lama left in 1959. Dolkar's husband was killed during the uprising, leaving her with a family to raise alone. She said, "Although it was a very hard and sad time, having to leave and come to India brought these wonderful friends into my life."

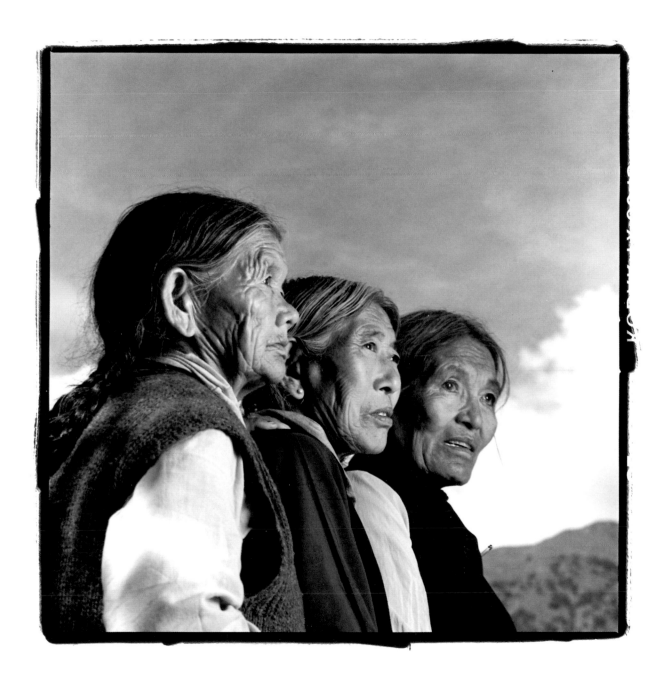

It does not matter whether we use religious or nonreligious practices to develop feelings of love and kindness.

What is important is that we each make a sincere effort to take seriously our responsibility for each other and the natural environment.

Sisi 8, Norsum 8
Parka, Tibet

Sisi and Norsum had just stayed up most of the night trying to save a premature baby goat. Unfortunately the goat died and they still had the early morning responsibility of caring for this rapeseed field. Even with the extremely short season at an altitude of 12,500 feet, their families are able to farm highland barley, beans, corn, and rice.

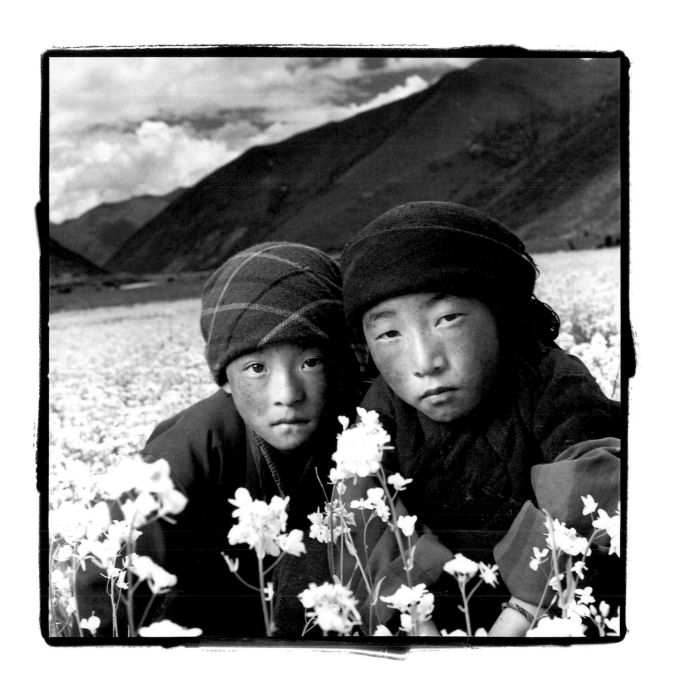

Compassion is not religious business,

it is human business, it is not a luxury, it is

essential for our own peace and mental stability,

it is essential for human survival.

Pusang 64 Dundup 32
Puga Valley, Ladakh

Pusang and Dundup are father and son. It was a very cold and windy day in December when I arrived at their nomad camp located at an altitude of 17,000 feet. They had just finished offering prayers prior to sacrificing two yaks for their winter food supply. Everything was so primal, it reminded me of what it might have been like to come across native peoples on the North American plains two hundred years ago.

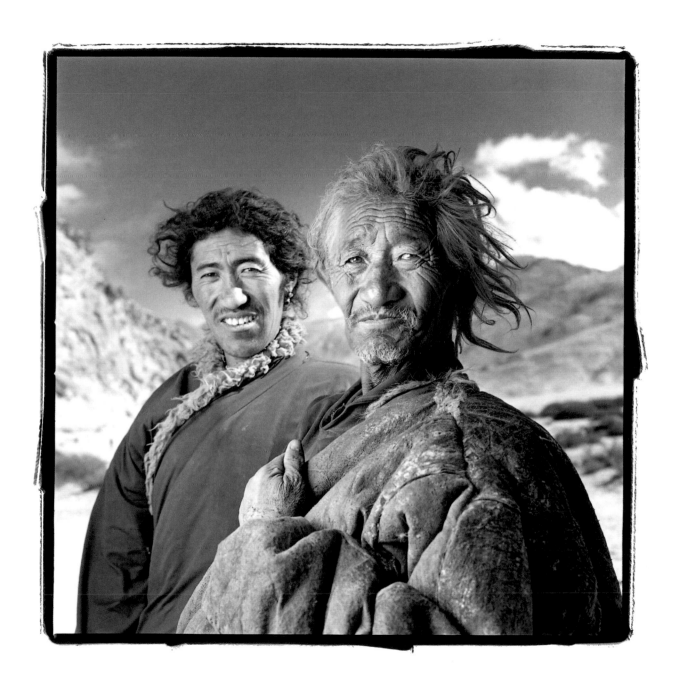

We are at the dawn of an age

in which extreme political concepts and dogmas

may cease to dominate human affairs.

We must use this historic opportunity to replace

them with universal human and spiritual values.

And ensure that these values become the fiber

of the global family which is emerging.

Yama 8
Lhasa, Tibet

Yama came with her parents and three sisters on a six-week pilgrimage to the Jokhang Temple in Lhasa from the province of Kham. "Yama helped carry our ten-month-old daughter much of the way," her mother said. "We noticed very early that she was born with the true spirit of wanting to help others."

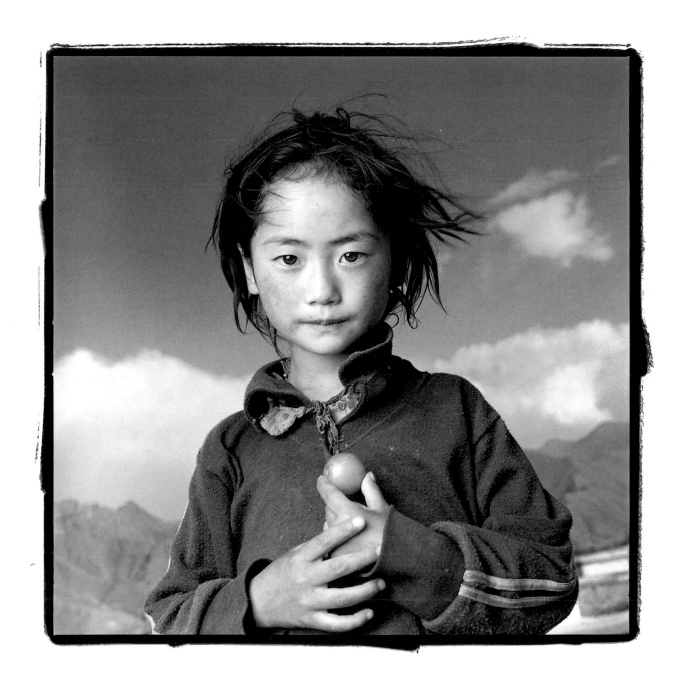

Epilogue

Elie Wiesel

In my student years in Paris at the Sorbonne I was drawn to Tibet and its unattainable secrets. Tibet appealed to the romantic wanderer and to the mystical Jew in me, for Tibet seemed to be the center of a strange world, the exotic place where humankind is obsessed with simplicity and penetrated by a quest for meaning in everyday affairs. Often I thought Tibet must be to some – perhaps to many – what Jerusalem is to me: a physical expression of a metaphysical longing for human compassion and divine presence. In trying to find common ground between Jews and Tibetans, I went so far as to wonder whether the Tibetan word *lama* is not actually taken from scripture. However, in Hebrew *lama* does not refer to monks or holy men; it means "why."

I hope you will not mind if I prefer the Hebrew translation, for it seems relevant. Why? is the question we ask when we discuss Tibet. Why has Tibet been forgotten for so long? Why has China chosen to invade it? China is so huge; why does it need Tibet? And why is the civilized world so complacent about it? Why aren't we using more efficiently our moral power, our political power, our intellectual power, our spiritual power to help a small nation with noble religious traditions? A nation that has been invaded by armies and repressed by totalitarian doctrines. Why are we silent when Tibet needs our voices?

This is especially poignant to some of us who believe in nonviolence, of which Tibet is an inspiring symbol. Tibet seeks neither territorial expansion

nor political domination. Tibet's only ambition is to be free and now to regain its freedom, its sovereignty. Isn't it every decent person's duty to stand at its side? If to be free is the most important goal of all, then to help someone else to be or become free must be the most sublime and rewarding of human endeavors.

Surely you have heard of the custom of gift sharing in the Orient. If you wish to bring joy to a friend, you offer him or her a cage with a bird in it. And it is your friend's privilege and joy to open that cage. Just imagine what our joy would be if we could help the Tibetans open their own cage. For that is what torments us. The Tibetans have now become prisoners in their own homes. To be a prisoner is bad, but to be a prisoner at home is worse. Why have we not tried sooner to free Tibetans from their prisons?

I believe we have a task to fulfill. I invite you to support the Tibetans in their nonviolent efforts to regain what has been taken from them.

Timeline

1949
China Invades Tibet

Ignoring the treaty signed by Tibet and China in A.D. 823 that defined their borders and recognized each other as sovereign nations, China's People's Liberation Army under Chairman Mao invades Tibet to "liberate" the Tibetan people.

1950 – present
Tibet Devastated by China's Occupation

An estimated 1.2 million Tibetans die from military actions, torture, forced labor, and starvation. One in ten Tibetans is held in prisons or forced labor camps for periods of 10 to 20 years. Tibet's natural resources and fragile ecology are being irreversibly destroyed.

1959
Dalai Lama Flees

The Dalai Lama's eight-year attempt to peacefully co-exist with the Chinese is unsuccessful. In March, a national uprising by the Tibetan people against the harsh Chinese occupation is brutally put down. The Dalai Lama and about 100,000 Tibetans are forced to flee, receiving political asylum in neighboring India.

1965 – 1972
Assault on Religion

During the Cultural Revolution, China attempts to eradicate Buddhism in Tibet. The Red Guards destroy all but 11 of the 6,200 monasteries. All religious items that were not hidden are destroyed – scriptures burned, clay objects smashed, and carved sacred stones used for construction.

1984
China Begins Massive Population Transfer

China recruits and offers financial incentives to Chinese to settle in Tibet. In Tibet, authorities turn a blind eye to Chinese families that violate the one-child policy enforced in China. Though not an "official" policy, this adds another incentive for Chinese families to relocate to Tibet. By 1995, there were over 7.5 million Chinese to the 6 million Tibetans, making the transfer policy the major threat to the survival of Tibetan culture.

1987
Nonviolent Demonstrators Killed

Chinese military invades Jokhang Temple and Drepung Monastery arresting monks and firing on unarmed protesters, killing and injuring many. These actions to control freedom of speech and religion are the first to be documented by foreign witnesses.

1989
Dalai Lama Receives Nobel Peace Prize

Citing the Dalai Lama's "constructive and forward-looking proposals for the solution of international conflicts, human issues and global environmental problems," the Nobel Committee awards him the Peace Prize.

1995
Human-Rights Abuses Continue

U.S. State Department reports that during 1994 "Chinese government authorities continued to commit widespread human rights abuses and in some instances tortured and killed detainees in Tibet."

The Dalai Lama's Peace Plan

The Dalai Lama has proposed a Five-Point Peace Plan for Tibet.

1. Transformation of Tibet into a zone of peace.
2. Abandonment of China's population transfer policy.
3. Respect for the Tibetan people's human rights and democratic freedoms.
4. Restoration and protection of Tibet's natural environment—no production of nuclear weapons or dumping of nuclear waste.
5. Commencement of negotiations on the future status of Tibet and of relations between the Tibetan and Chinese peoples.

In resolutions passed in 1959, 1961, and 1965, the United Nations called on China to respect the human rights of Tibetans and their right to self-determination.

In 1991, the U.S. Congress passed a resolution that declared Tibet an occupied nation whose true representatives are the Dalai Lama and the Tibetan government-in-exile.

The Roof of the World

Bordered to the north by the Kunlun mountain range and to the south by the Himalayas Tibet covers an area the size of Western Europe with an average elevation of 16,000 ft. above sea level.

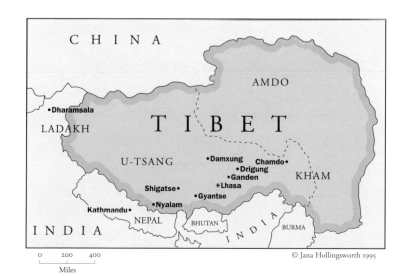

© Jana Hollingsworth 1995

Production Notes

The Prints

Camera
Hasselblad 500CM
Lenses: 80CT* and 150CT*

Lights
Lumedyne 400ws battery-pack
Diffusion: 2' x 3' softbox

Film
Kodak Tri-X rated at 200 ASA;
developed I:I D76 10 min
Polaroid 664

Paper
Ilford Multigrade III fiber base.
All prints were selectively toned
using Kodak sepia toner